Leelanau Underwater

Exploring Shipwrecks in Leelanau County and the Manitou Passage

© Chris Roxburgh

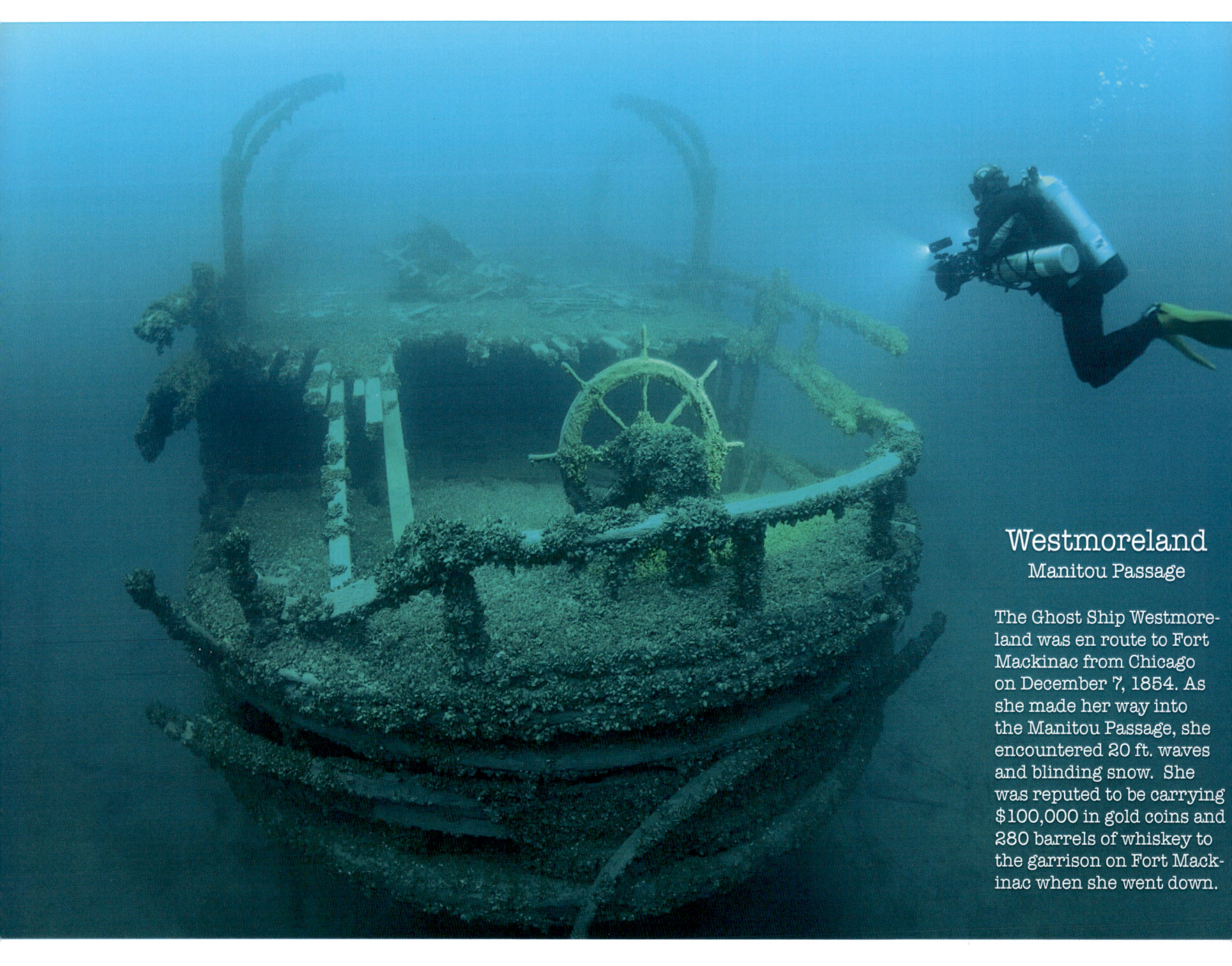

Westmoreland
Manitou Passage

The Ghost Ship Westmoreland was en route to Fort Mackinac from Chicago on December 7, 1854. As she made her way into the Manitou Passage, she encountered 20 ft. waves and blinding snow. She was reputed to be carrying $100,000 in gold coins and 280 barrels of whiskey to the garrison on Fort Mackinac when she went down.

The anchor still hangs off of the bow.

As she pounded through the waves, the Westmoreland was leaking and the bucket brigade could not keep up with the increasing flow of water. Her boilers where extinguished and she could no longer steer into the oncoming waves.

4 Westmoreland - Manitou Passage

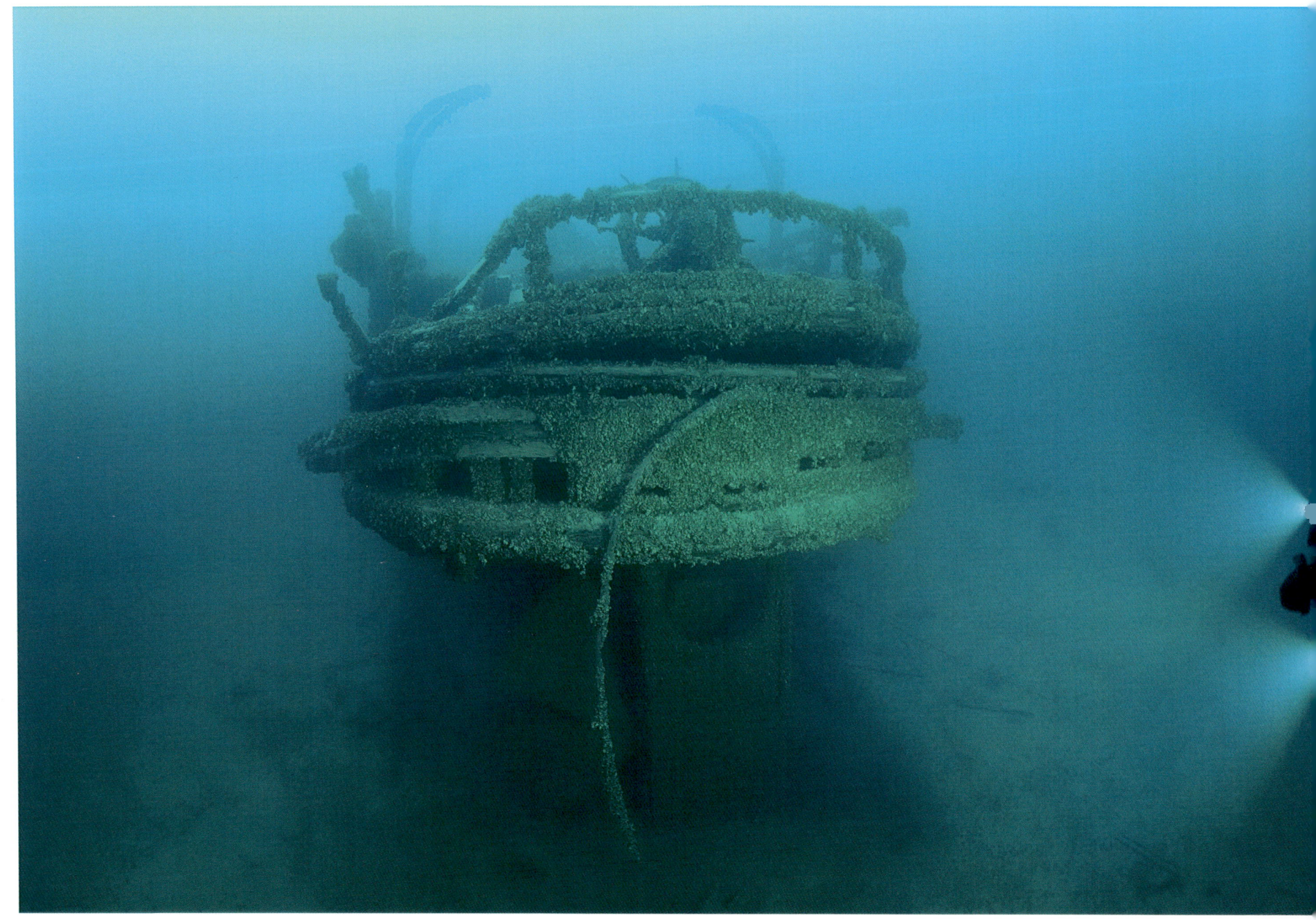

"She sits upright with many stories to tell."

After losing her steam power, Lake Michigan quickly pulled the Westmoreland under, taking half of the crew down with her. The remaining crew managed to get to shore as two more perished from the freezing cold weather. After walking for 40 miles, the survivors reached shelter.

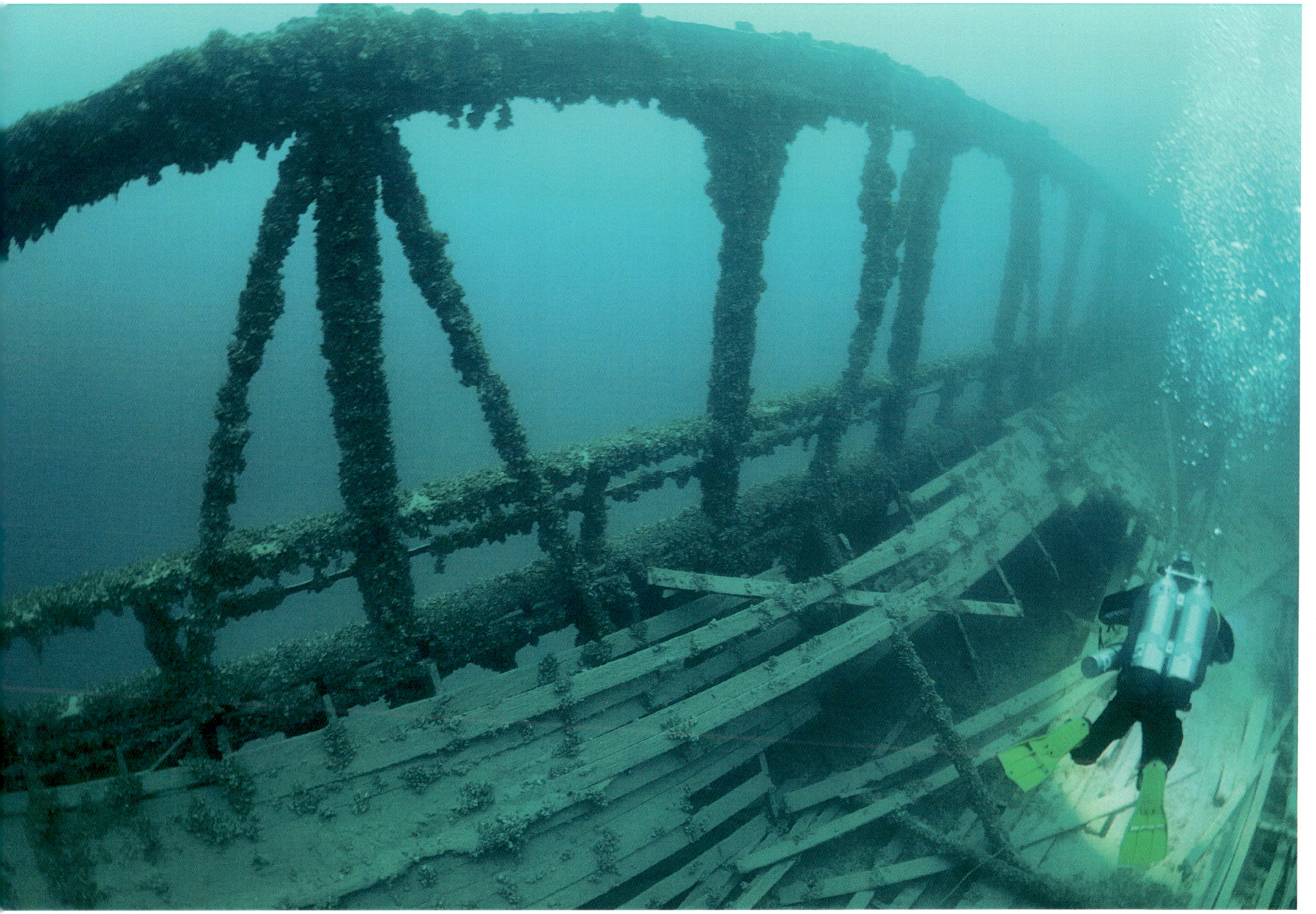

"The Hogging Arches"

Hogging Arches were installed to limit flexing of the 200 ft. long hull. For over 150 years, the Westmoreland was searched tirelessly by many shipwreck hunters hoping to find her gold and whiskey cargo. In 2010, Ross Richardson located her final resting place 200 ft. deep in the Manitou Passage.

6 Westmoreland - Manitou Passage

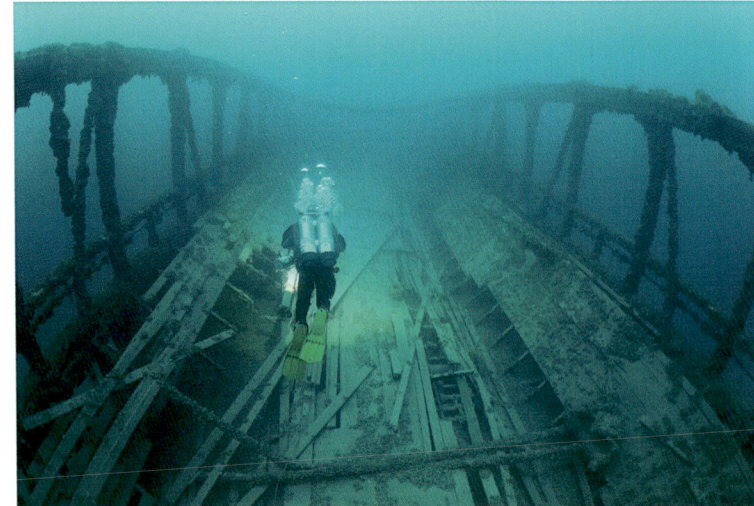
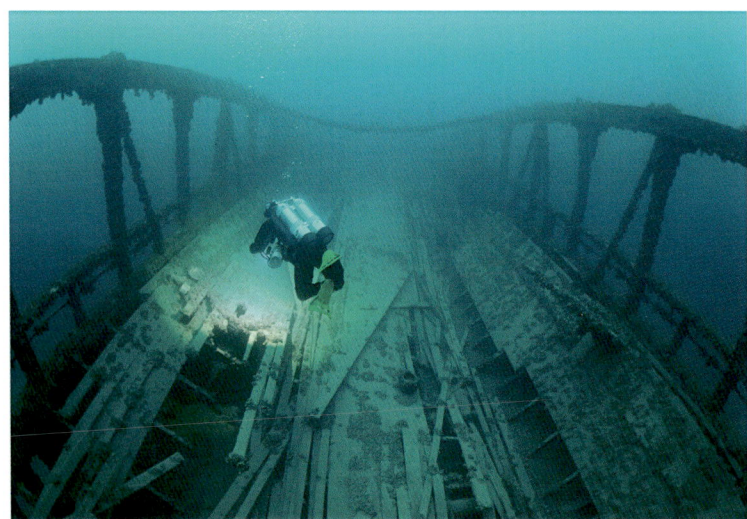

The Westmoreland's hogging arches are still intact as we approach ornate artifacts on her deck.

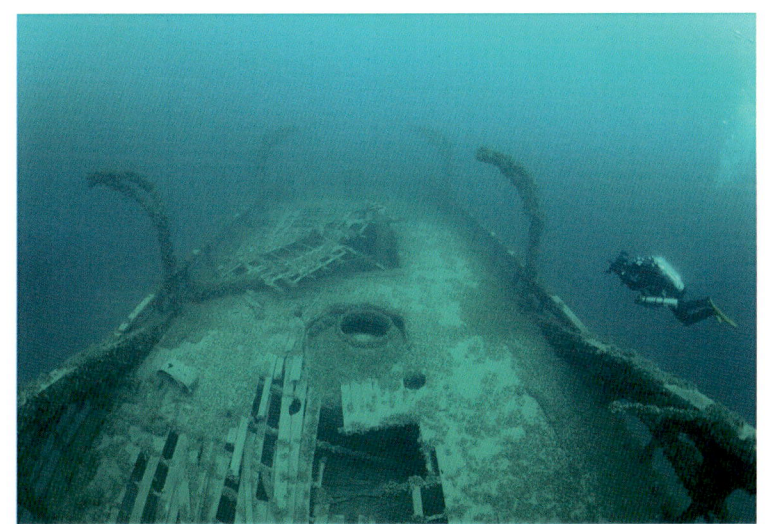
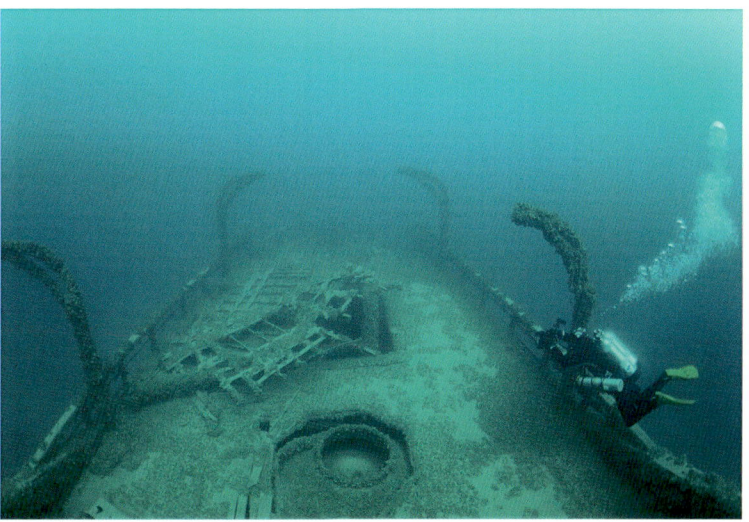

Empty lifeboat davits are in place, telling a tragic story of loss and survival.

George Rogers
Northport

The George Rogers was a small tug that caught fire and ran aground near Peterson Park, Northport.

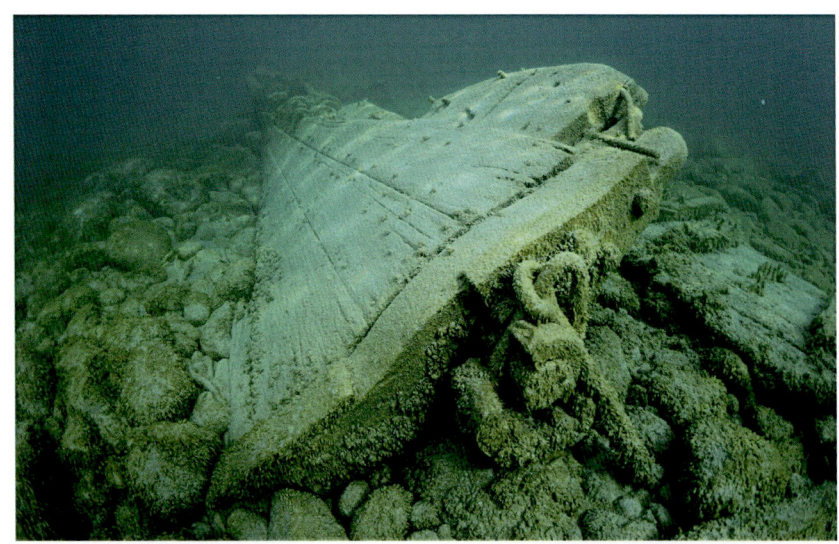

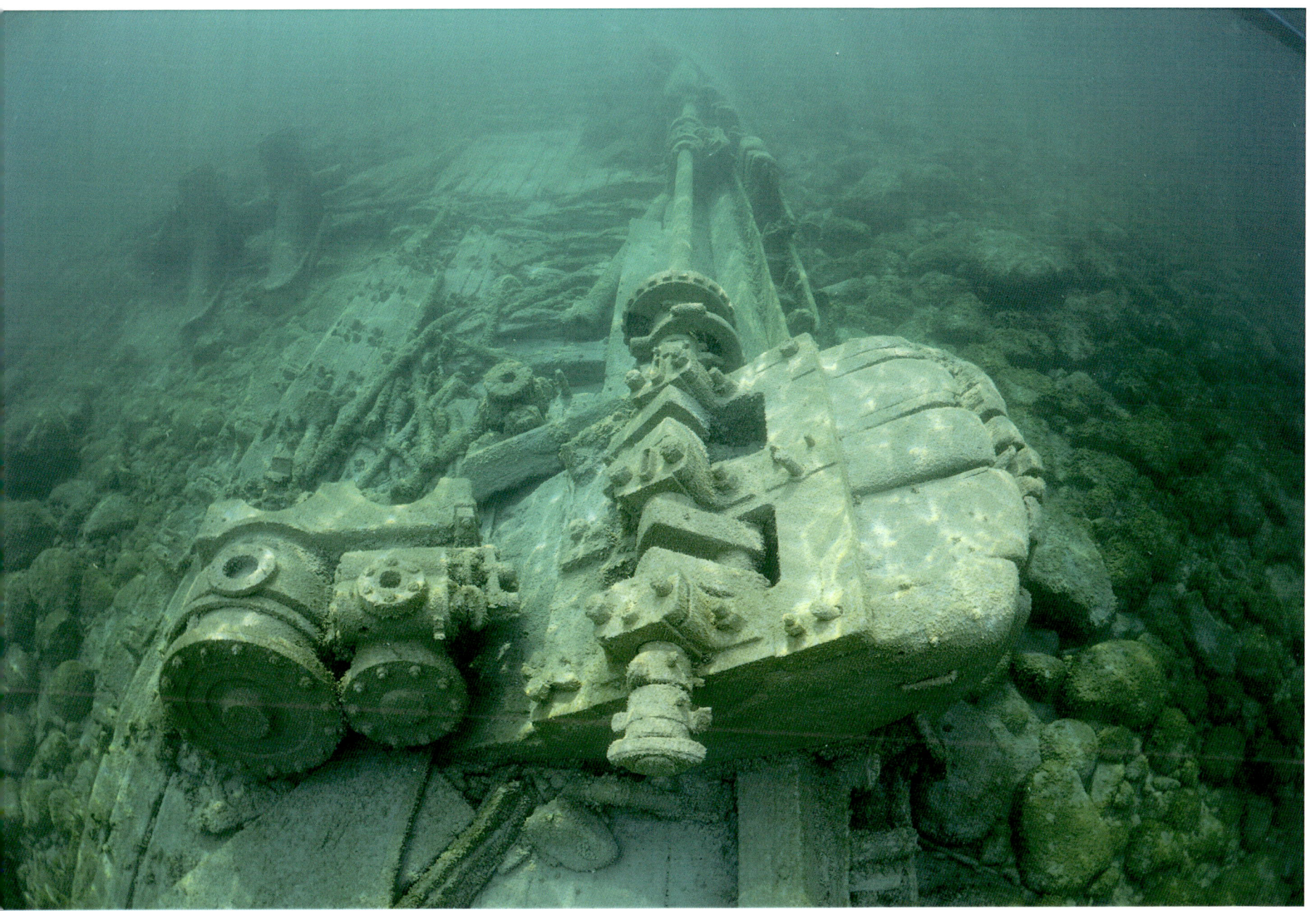
Three men on the George Rogers made it to shore with no lives lost.

10 George Rogers

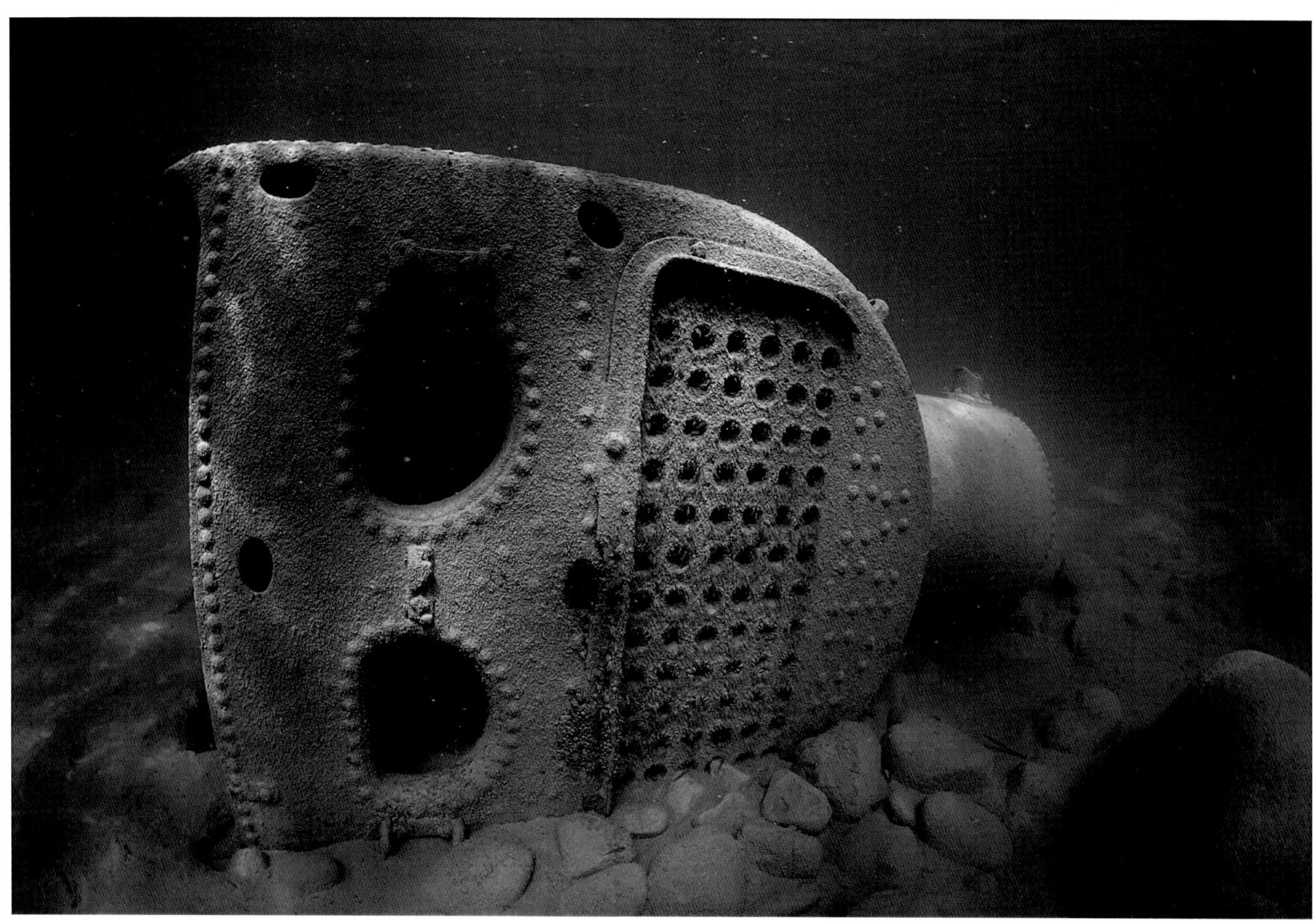

The boiler from the George Rogers is located north of the shipwreck, almost in front of Peterson Park, Northport, Michigan.

Vega
South Fox Island

The Vega was a bulk freighter built in Cleveland, Ohio in 1893. While shipping iron ore from Escanaba, she floundered off of South Fox Island on November 29, 1905.

12 Vega - South Fox Island

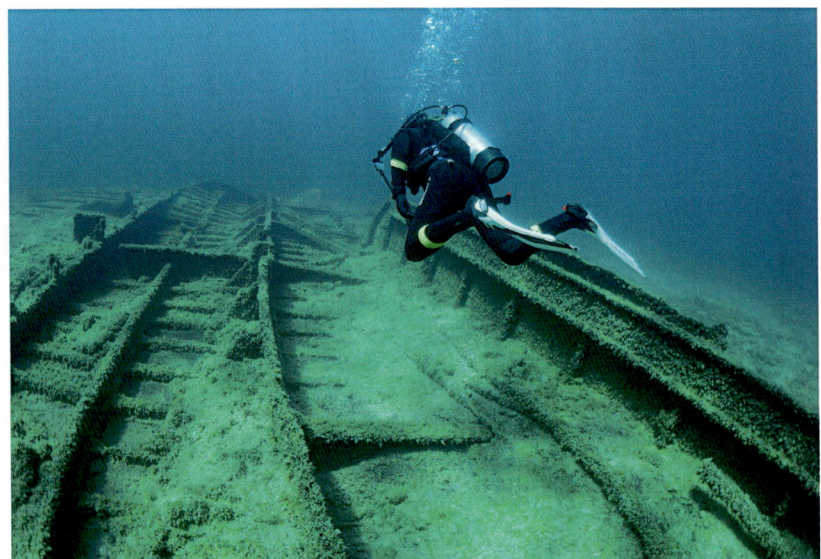

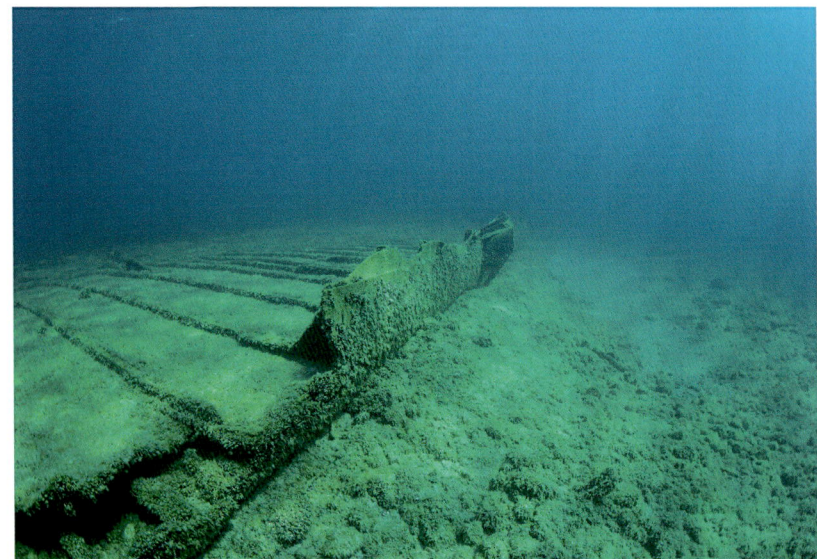

Gale winds blew the Vega into the rocks off of the shore of South Fox Island. The crew was rescued by Native American fishermen.

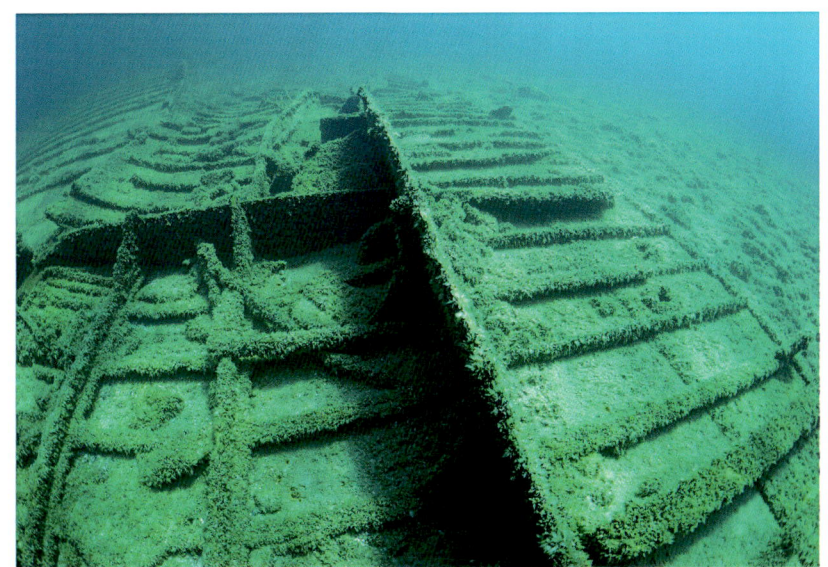
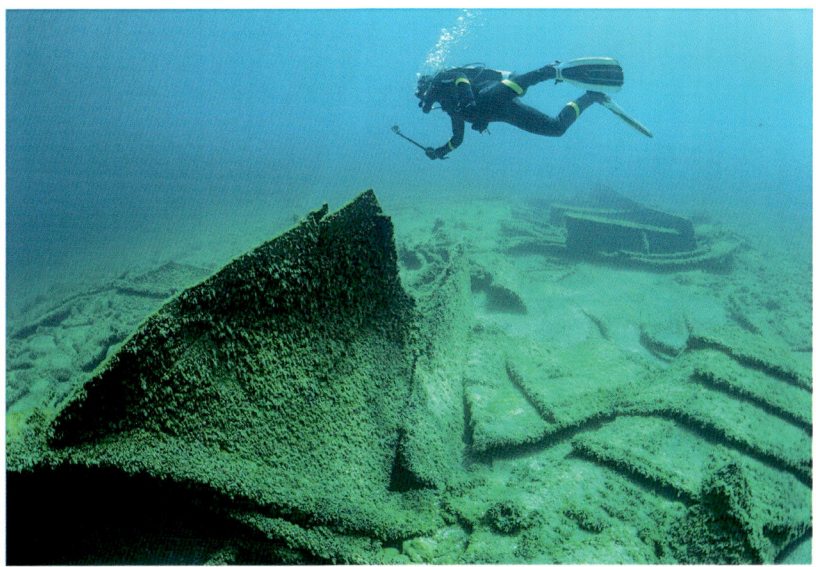

Over 100 years of wind and ice damage from Lake Michigan has torn apart the Vega, flattening her along the bottom.

Unidentified Rabbit Steamer
North Fox Island

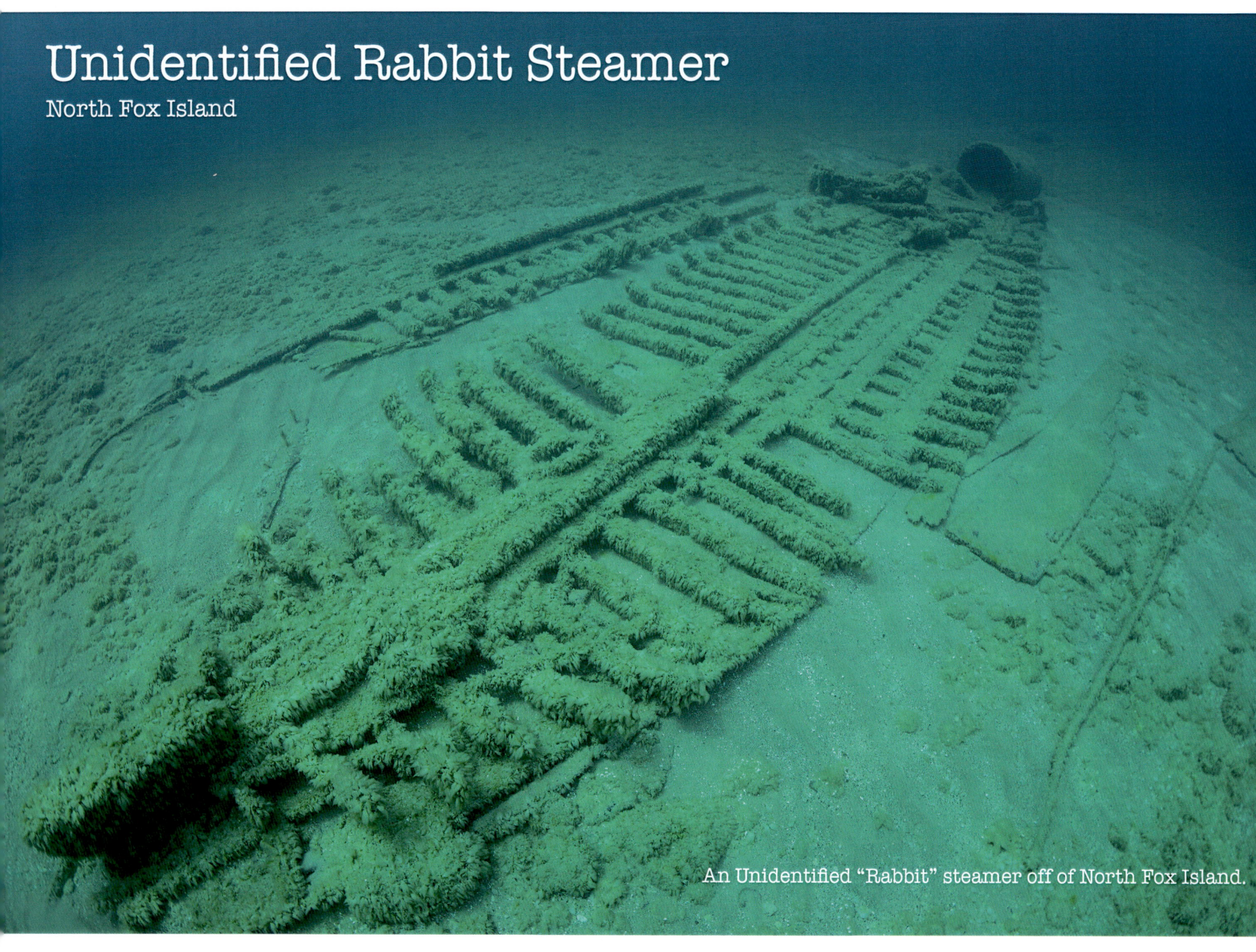

An Unidentified "Rabbit" steamer off of North Fox Island.

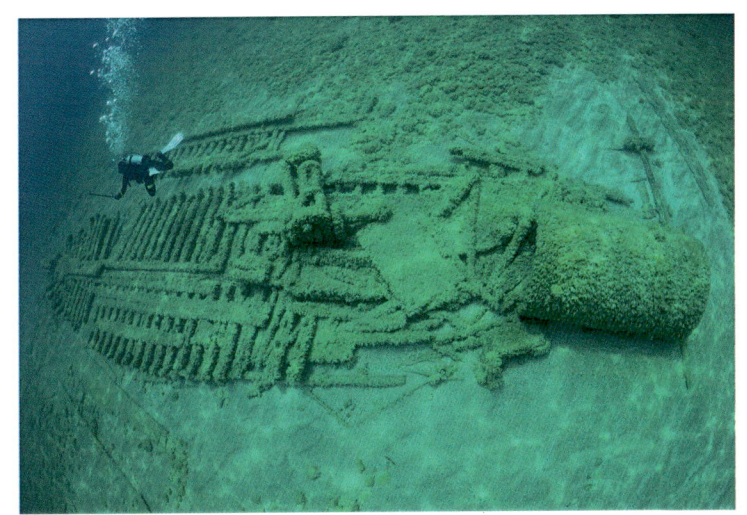

The cold, fresh Lake Michigan water has preserved the Rabbit steamer for many years.

16 Unknown Rabbit Steamer - North Fox Island

The unidentified Rabbit steamer has a unique boiler and build.

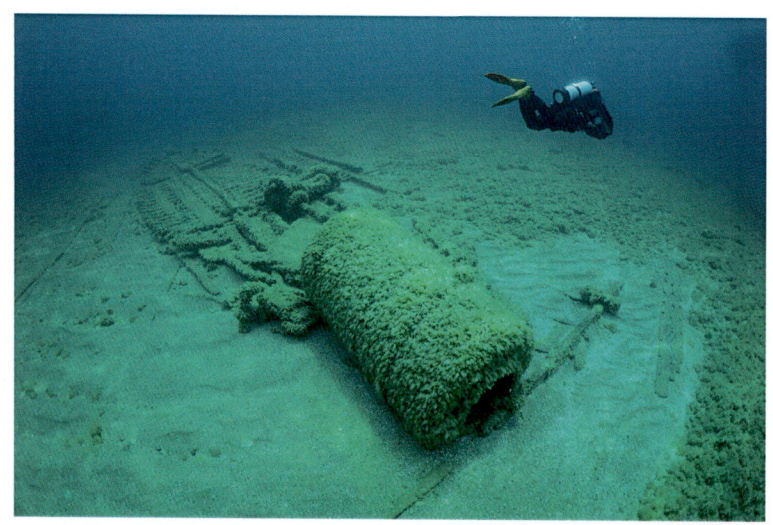

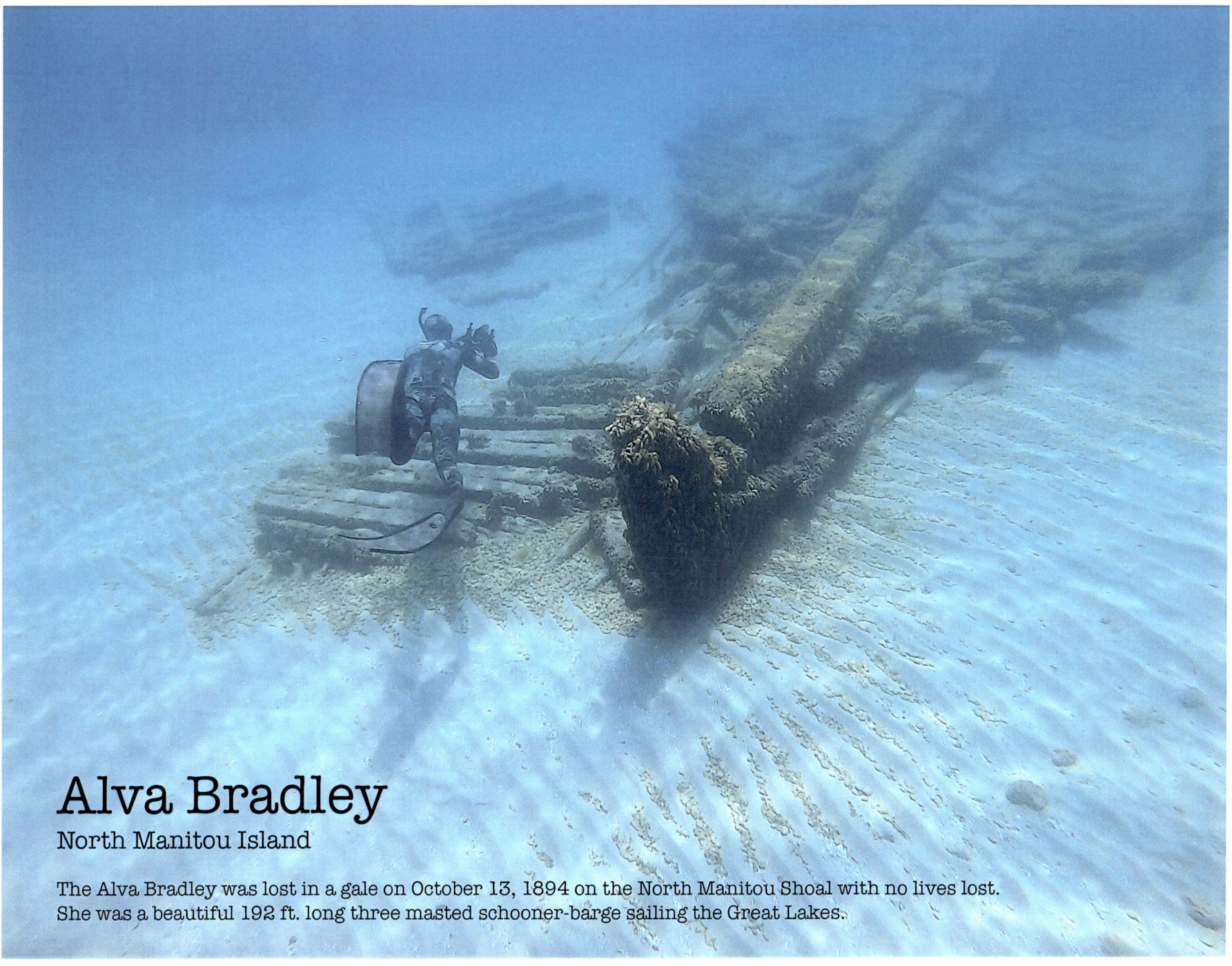

Alva Bradley
North Manitou Island

The Alva Bradley was lost in a gale on October 13, 1894 on the North Manitou Shoal with no lives lost. She was a beautiful 192 ft. long three masted schooner-barge sailing the Great Lakes.

18 Alva Bradley - North Manitou Island

The Alva Bradley has artifacts around the wreck site including steel billets, chains, and dead-eyes.

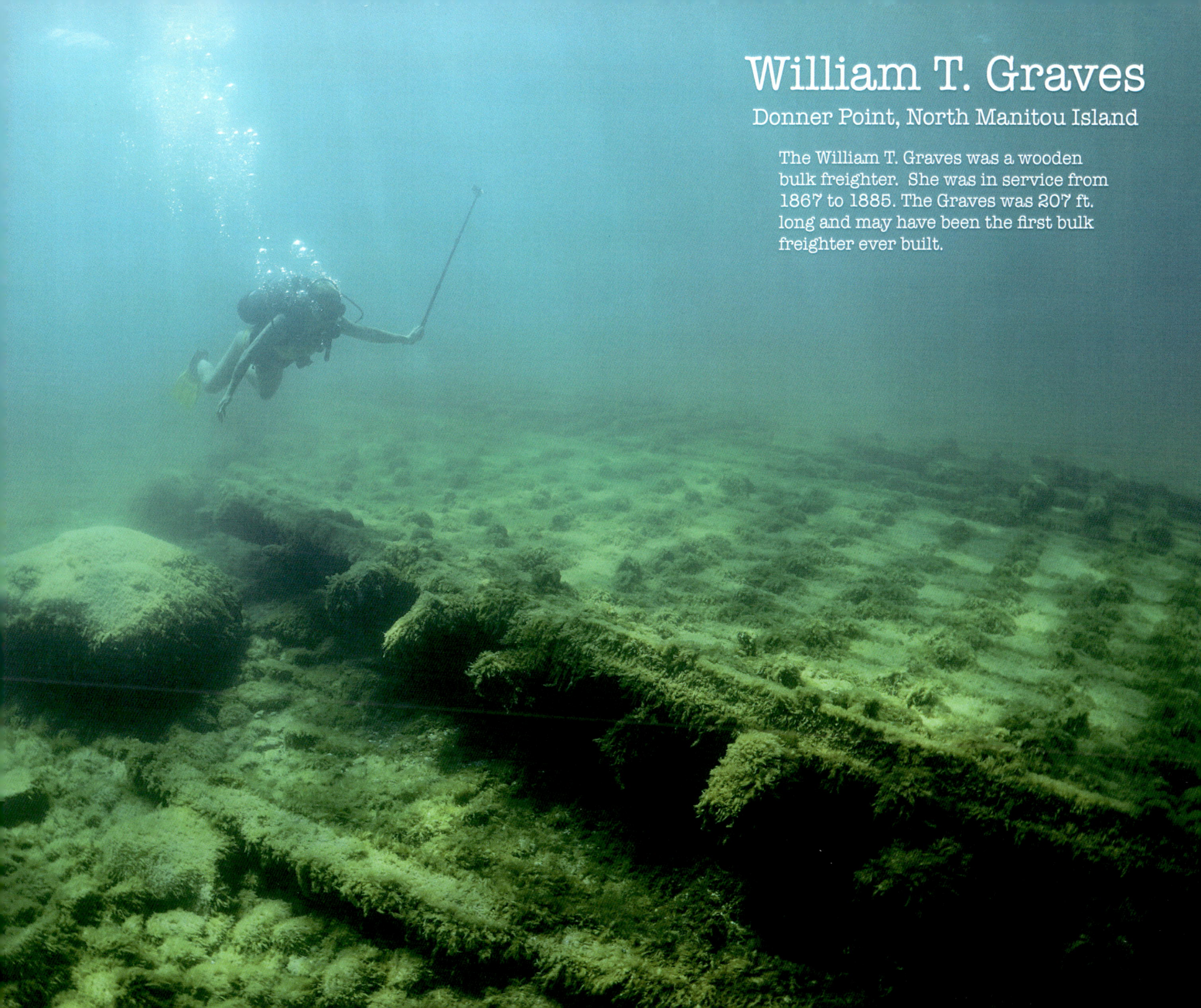

William T. Graves
Donner Point, North Manitou Island

The William T. Graves was a wooden bulk freighter. She was in service from 1867 to 1885. The Graves was 207 ft. long and may have been the first bulk freighter ever built.

In a heavy storm on October 31, 1885 the Graves ran aground at midnight off of Donner Point, North Manitou Island with no lives lost.

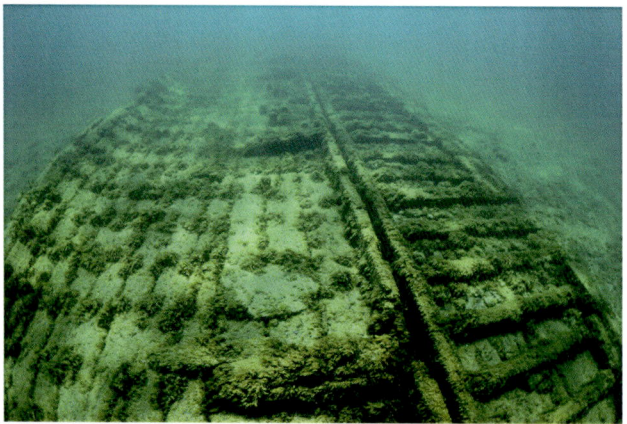

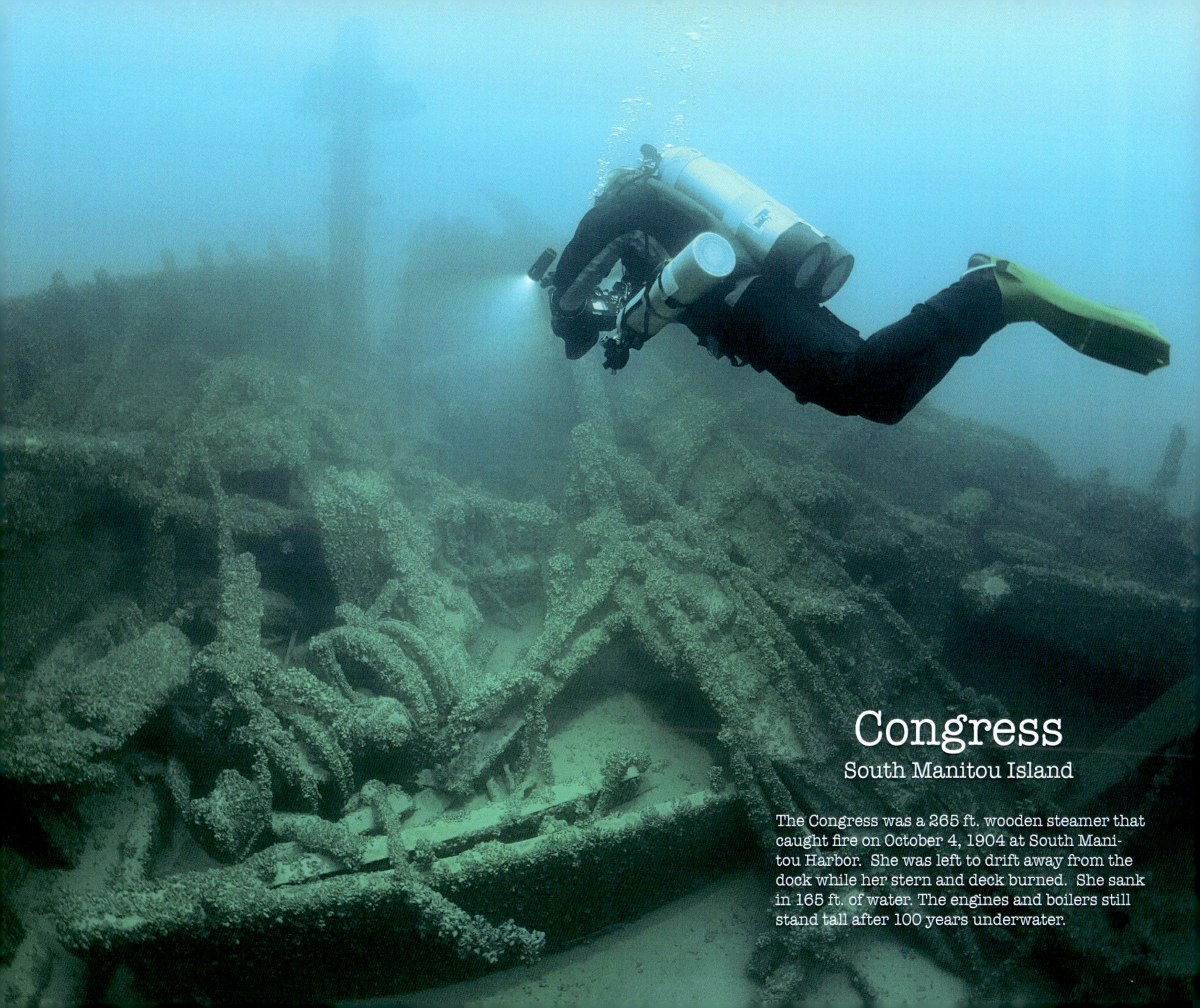

Congress
South Manitou Island

The Congress was a 265 ft. wooden steamer that caught fire on October 4, 1904 at South Manitou Harbor. She was left to drift away from the dock while her stern and deck burned. She sank in 165 ft. of water. The engines and boilers still stand tall after 100 years underwater.

22 Congress - South Manitou Island

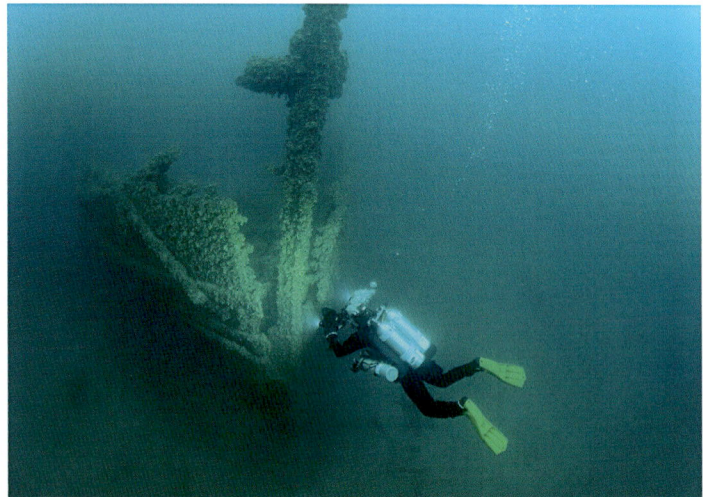
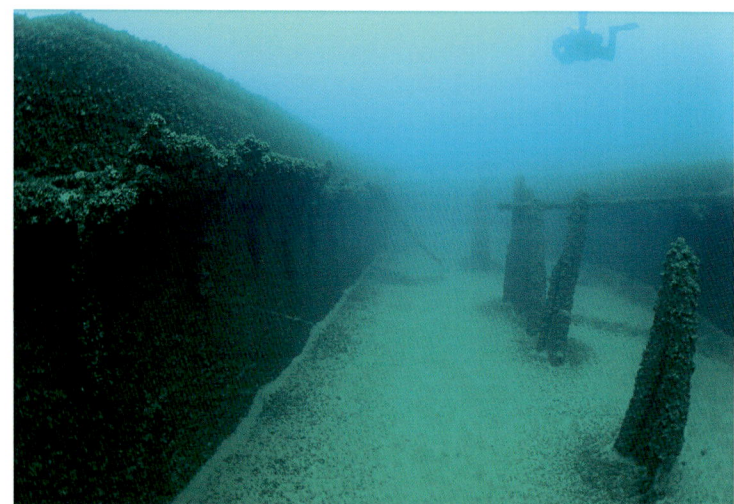

Congress's bow is still intact with anchor, windless, and ropes strewn across the bow. She sank to the bottom of South Manitou harbor with no lives lost.

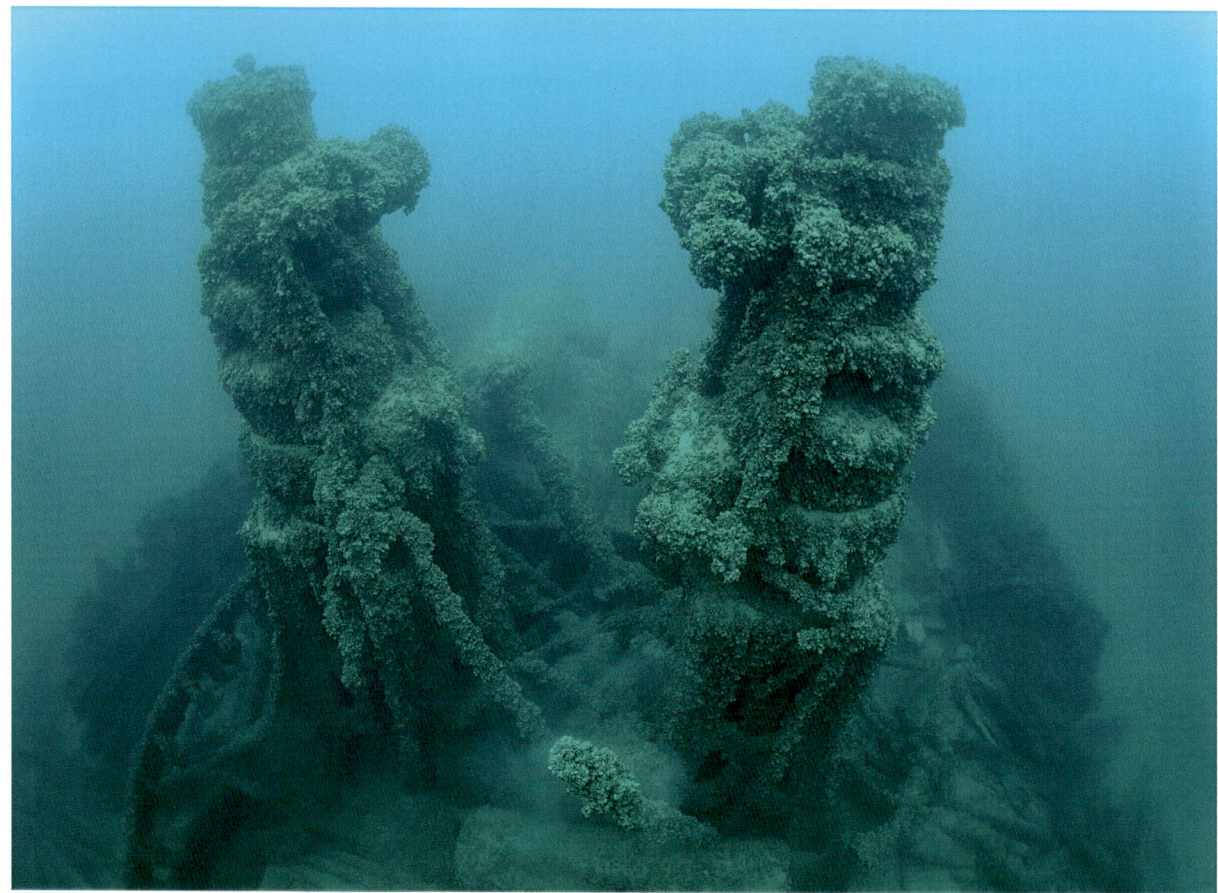

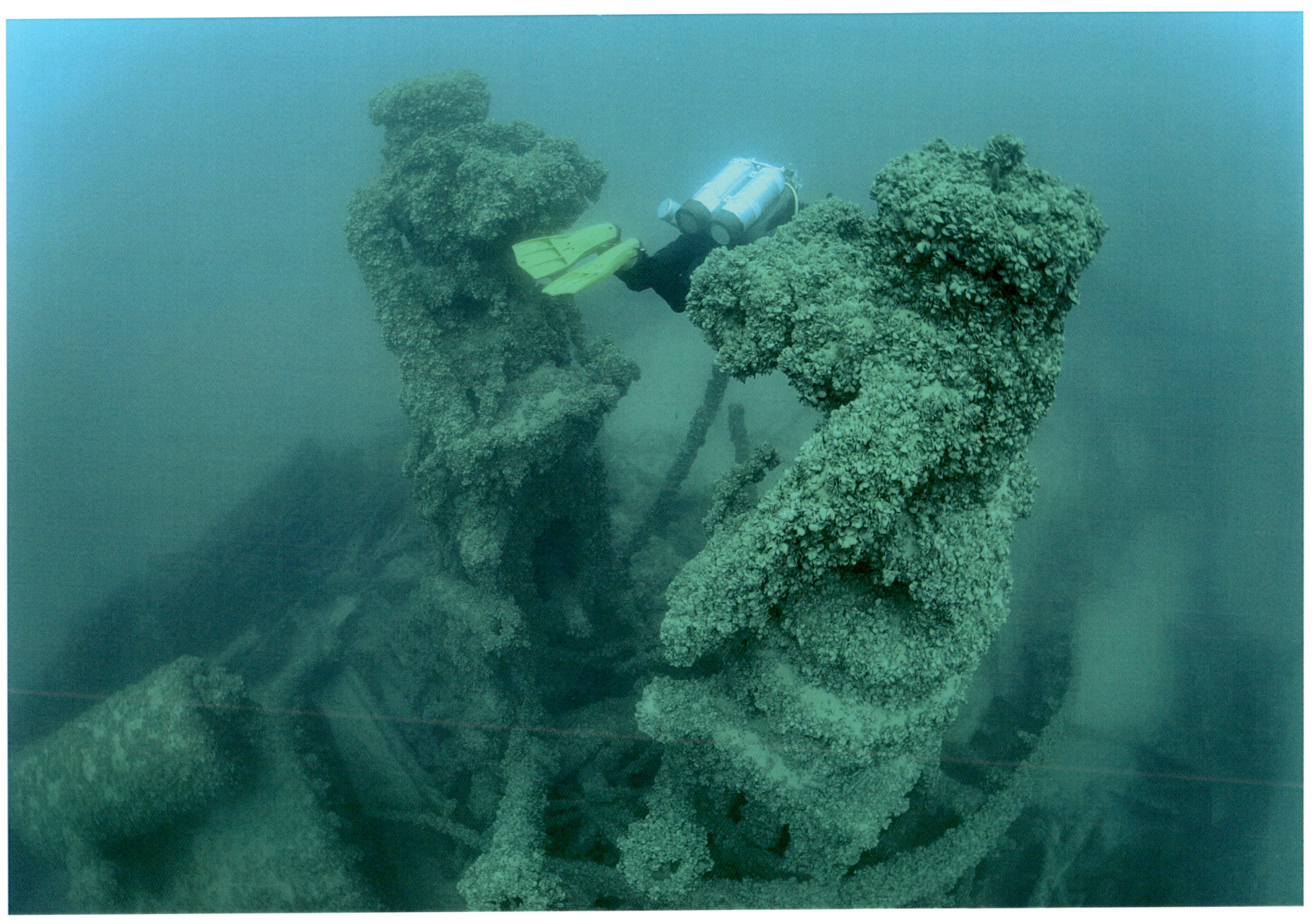

Congress's tall steam engine rises up off of the old wooden steamer, frozen in time for over 100 years. You can imagine this great vessel powering across Lake Michigan as smoke billowed out of her boiler stacks.

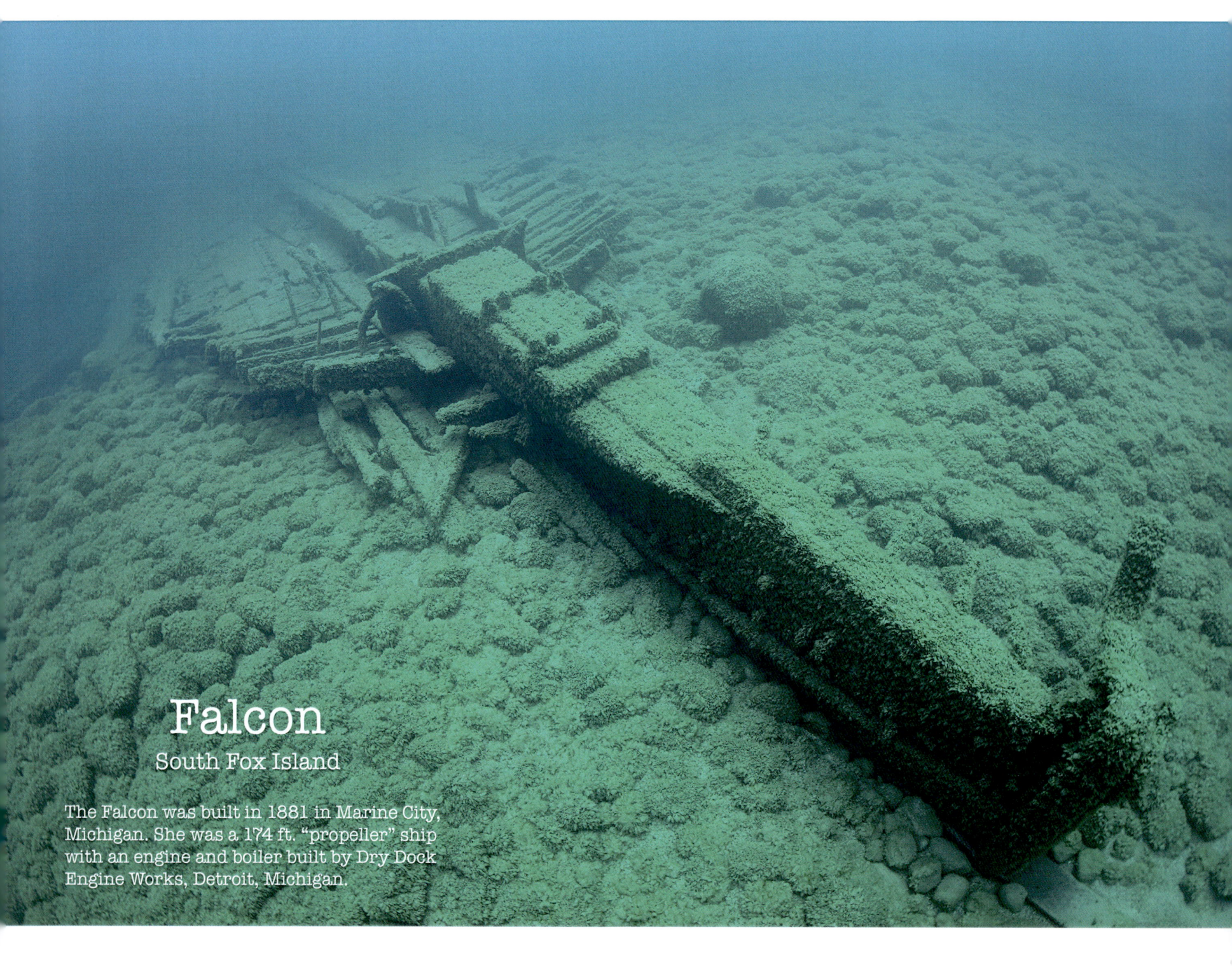

Falcon
South Fox Island

The Falcon was built in 1881 in Marine City, Michigan. She was a 174 ft. "propeller" ship with an engine and boiler built by Dry Dock Engine Works, Detroit, Michigan.

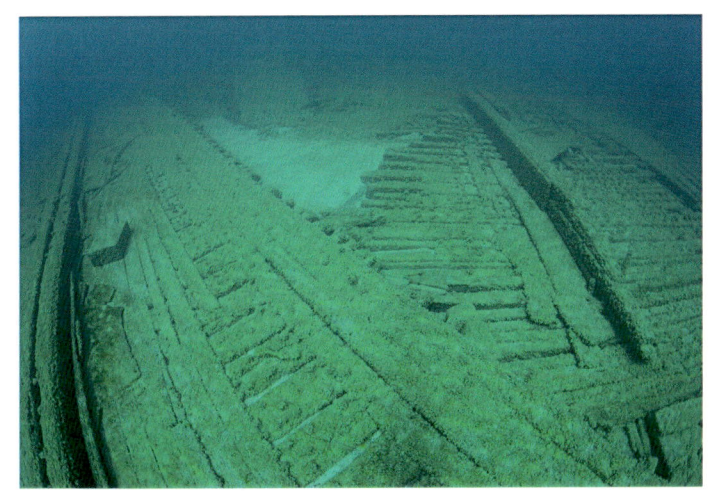
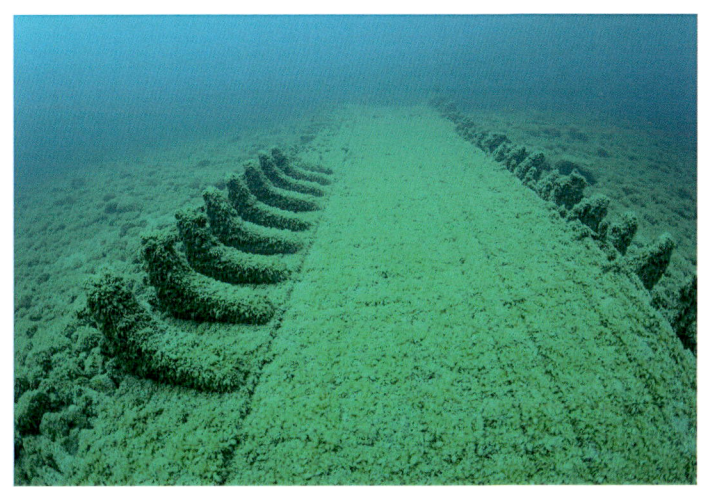

The Falcon ran aground on November 7, 1909 with 13 crew off of South Fox Island with no lives lost. It was originally built as the Kate Buttironi, then renamed the Falcon in 1901.

26 Falcon - South Fox Island

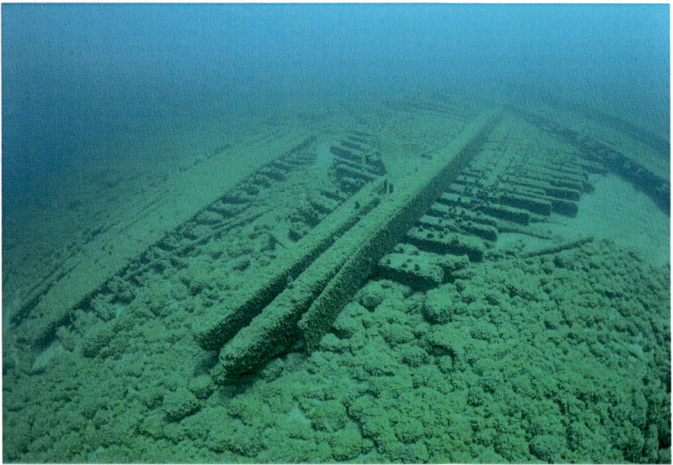
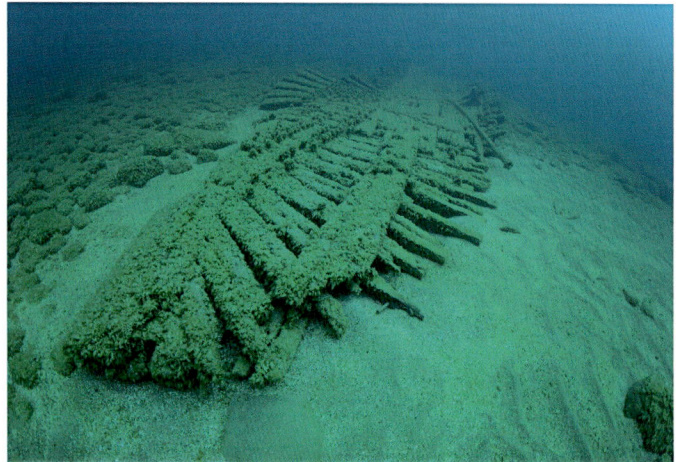

With a heavy load of iron ore, the Falcon broke into pieces from gale winds.

Unidentified Wrecks
Fox Islands

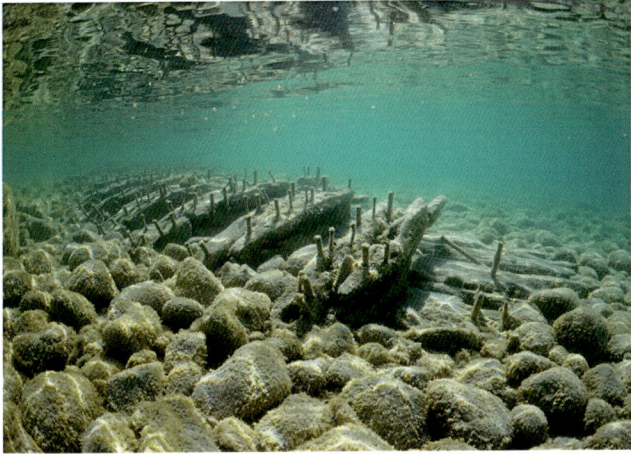
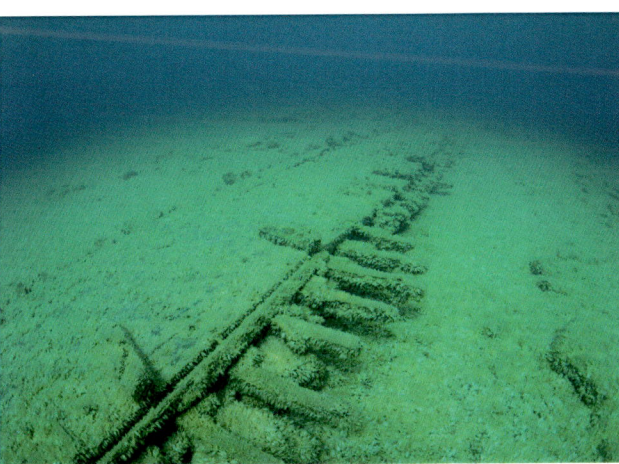

Various unidentified wreck sites around the Fox Islands in Lake Michigan.

28 Unidentified Wrecks - Fox Islands

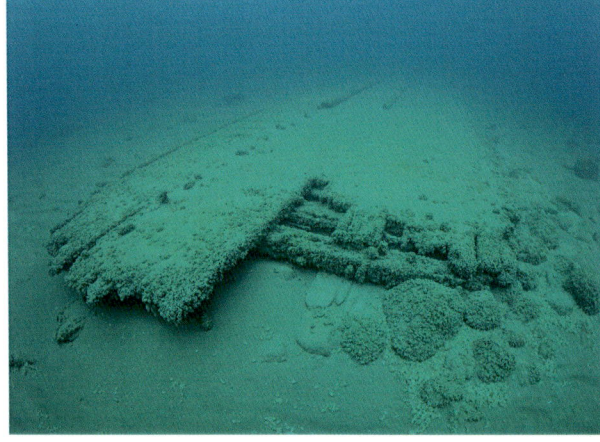
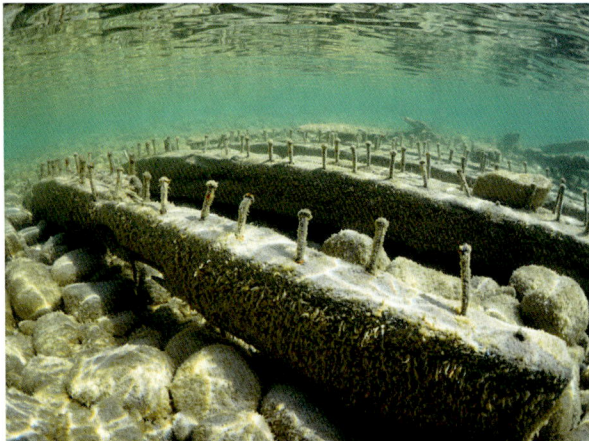

Boiler, above, and unidentified shipwrecks around the Fox Islands, Lake Michigan.

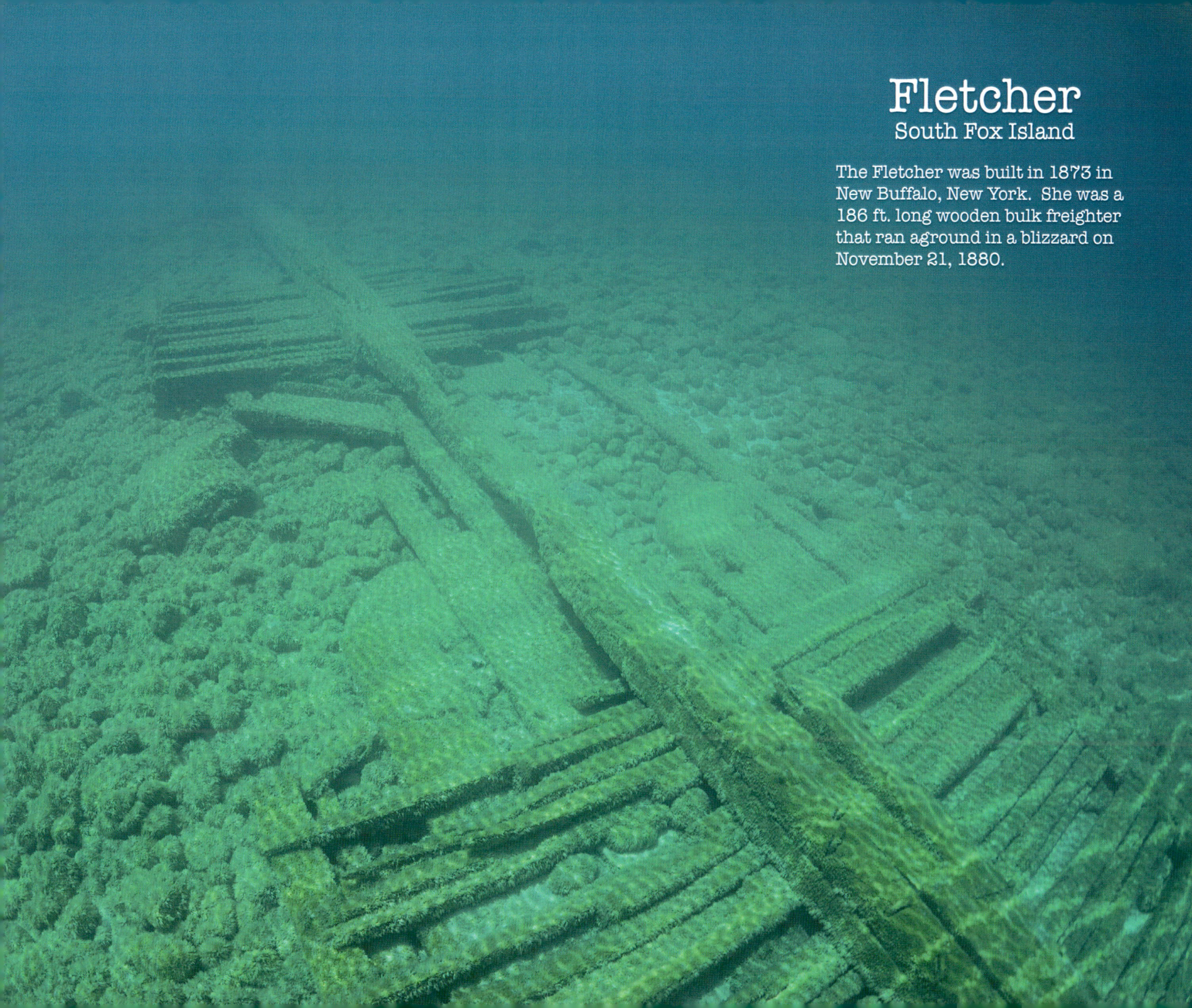

Fletcher
South Fox Island

The Fletcher was built in 1873 in New Buffalo, New York. She was a 186 ft. long wooden bulk freighter that ran aground in a blizzard on November 21, 1880.

Fletcher's boiler can be seen from the surface on a calm day.

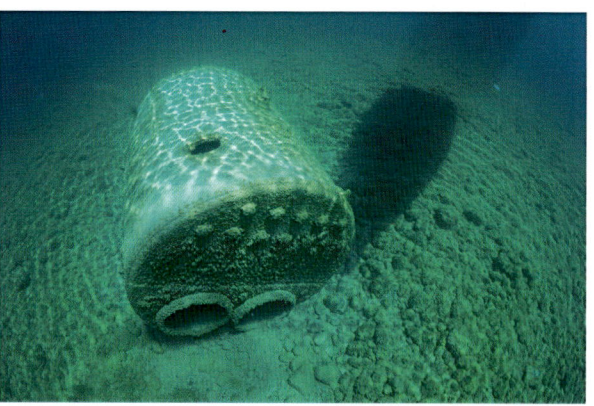

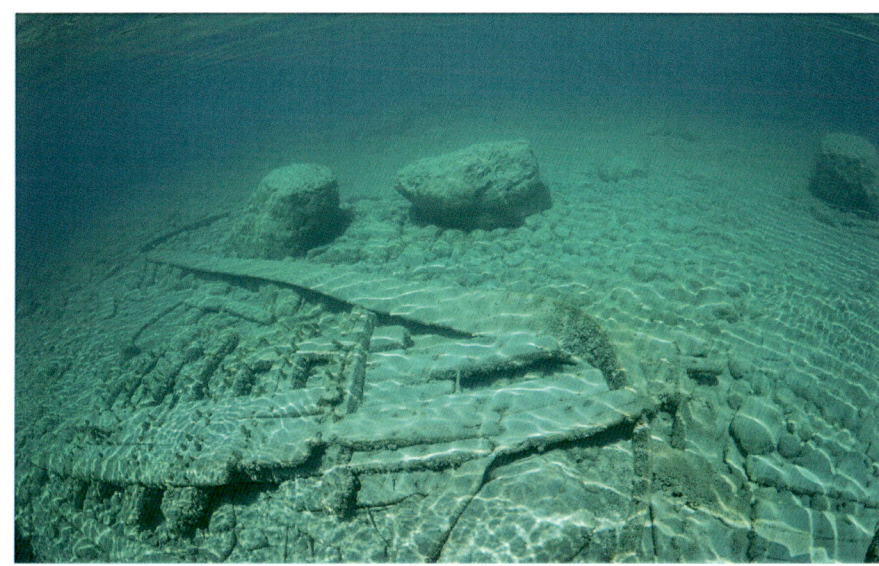

The Fletcher wreck site consists of three areas as she broke apart. Reports from the crew state that she was smashed to pieces along the rocky shoreline. No lives were lost.

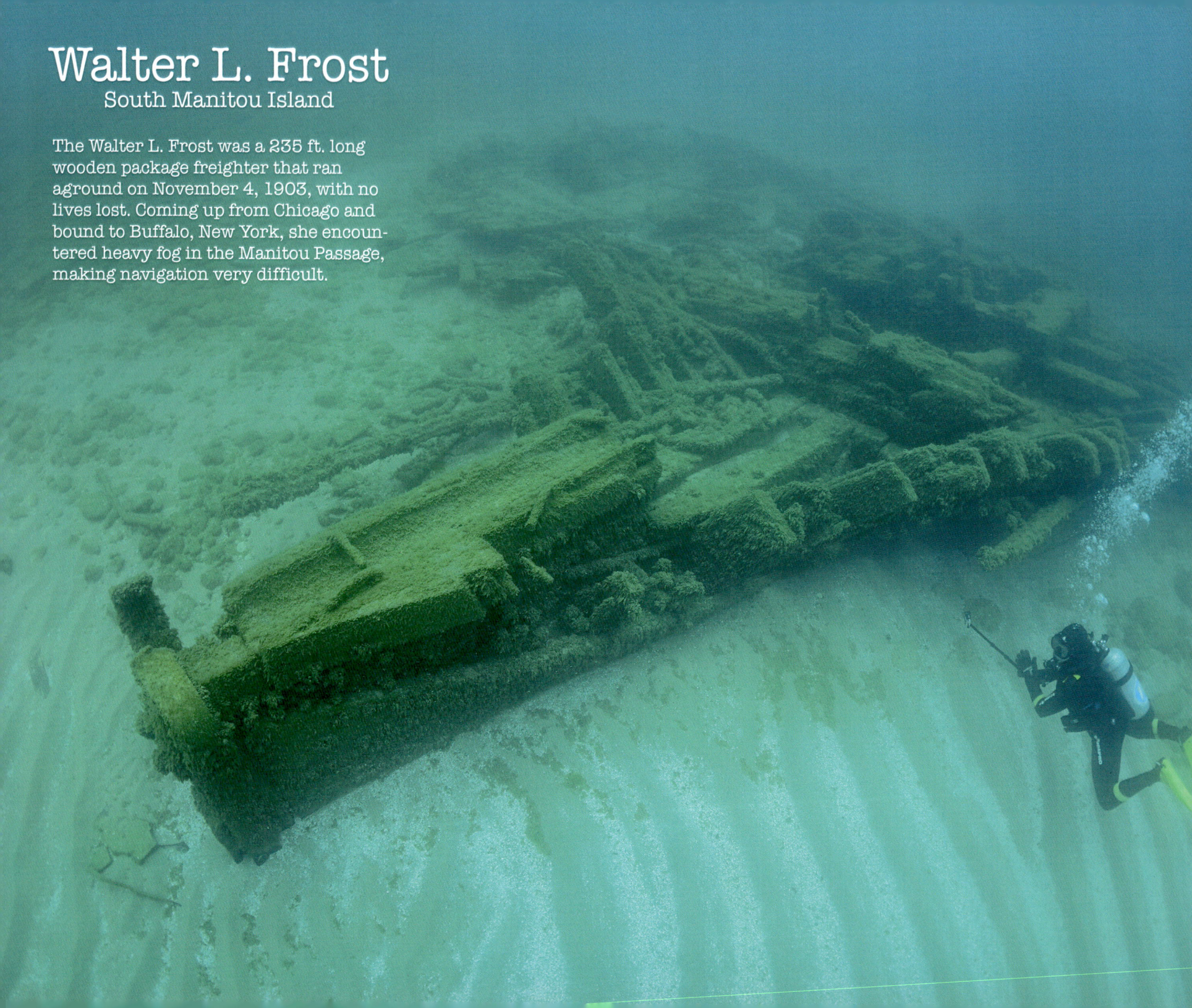

Walter L. Frost
South Manitou Island

The Walter L. Frost was a 235 ft. long wooden package freighter that ran aground on November 4, 1903, with no lives lost. Coming up from Chicago and bound to Buffalo, New York, she encountered heavy fog in the Manitou Passage, making navigation very difficult.

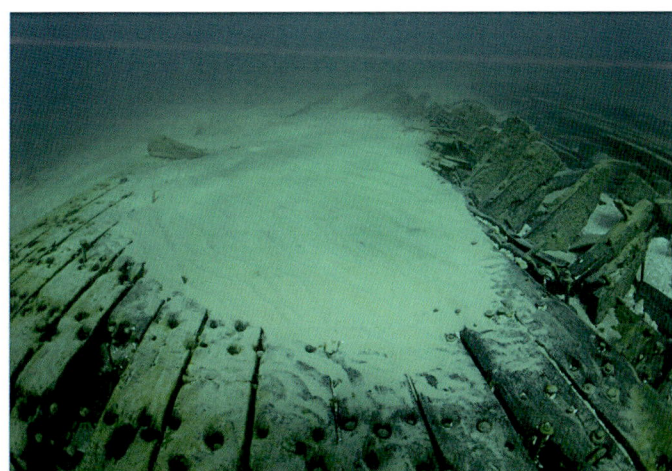
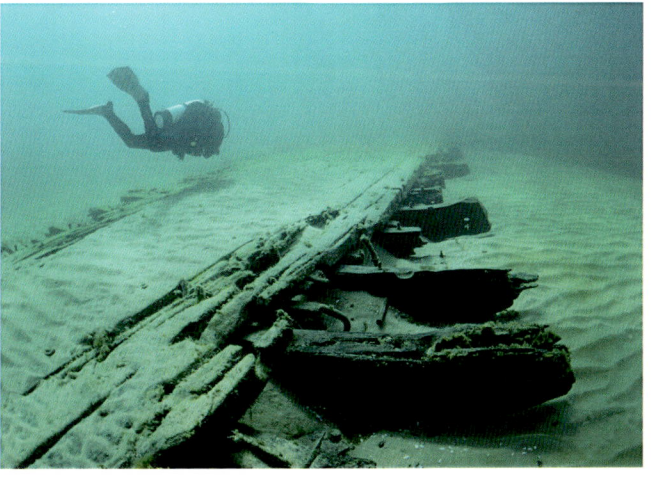

The crew from the South Manitou lifesaving station heard the Frost's distress whistle and launched a surf boat. They followed the whistle sound and rescued her crew. On November 29, 1960, the Frost was run over and broken apart by another vessel named the Francisco Morazan. Both still remain next to each other just off of the Island.

Rising Sun
Pyramid Point

The Rising Sun was a 133 ft. long wooden steamer built in Detroit, Michigan in 1884 for the House of David located near Benton Harbor. She was lost off of Pyramid Point, Maple City, Michigan on October 29, 1917, with no lives lost.

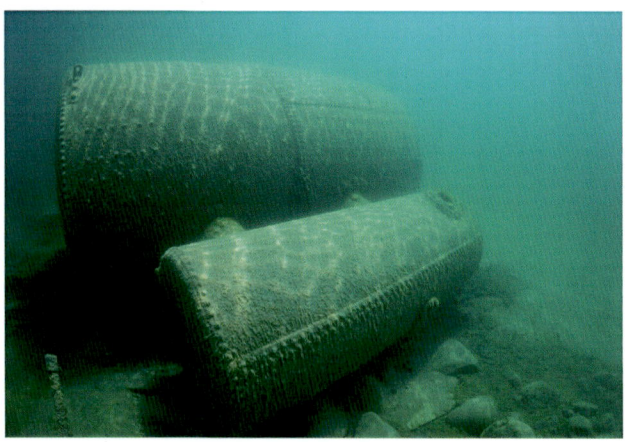
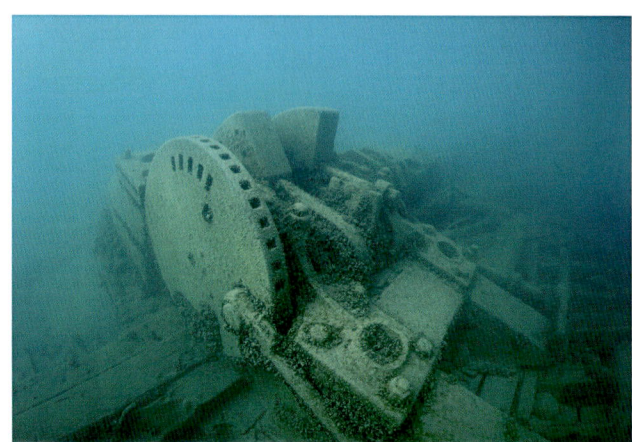

Supply
South Manitou Island

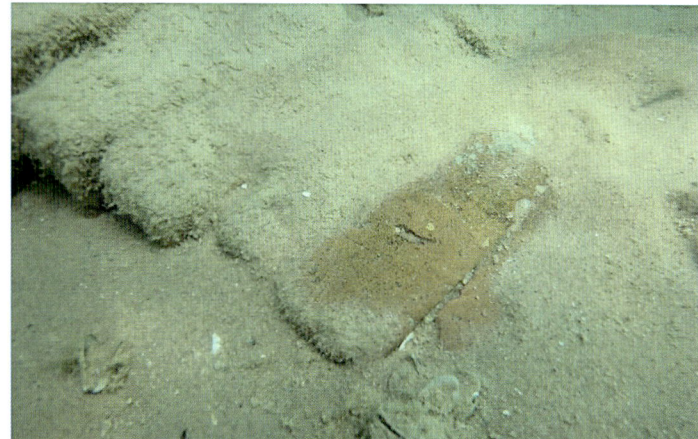

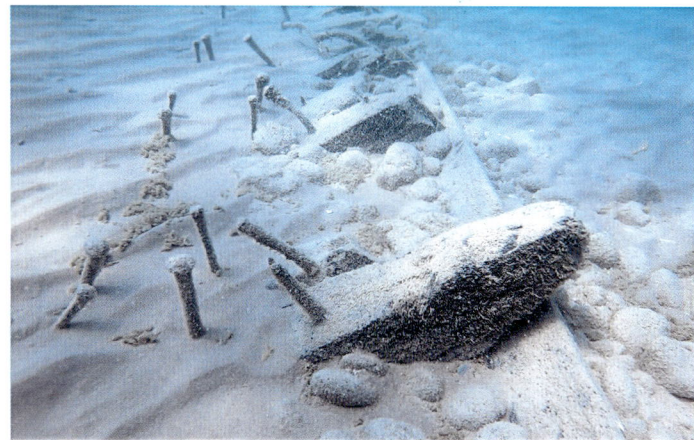

The Supply was a 132 ft. wooden brig built in Buffalo, New York in 1855. Her home port was Detroit, Michigan. She was lost in November, 1869 with one life lost. She carrying 300,000 bricks for a blast furnace, sinking like a brick while on her way to Carp River, present-day Leland, Michigan.

Unidentified Shipwreck
North Manitou Island

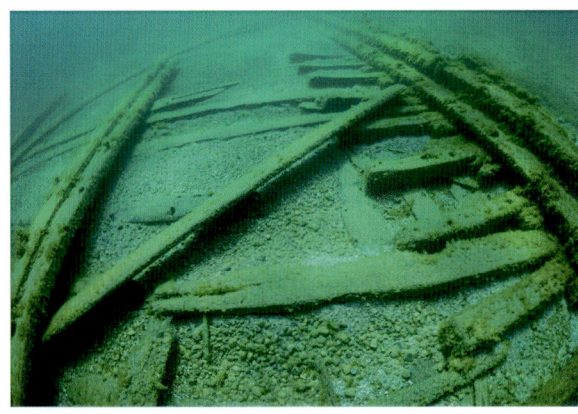
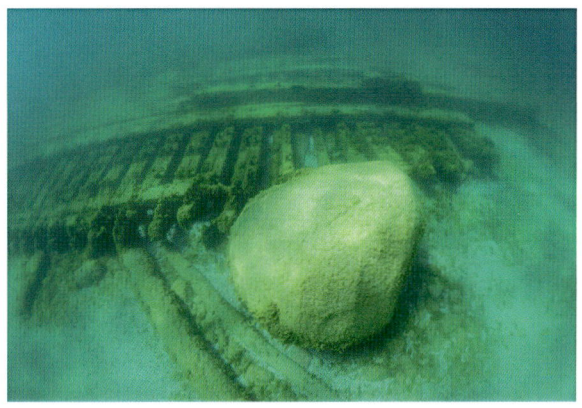

Donner Point Wreck
North Manitou Island

This unidentified wreck is near the shore along Donnor Point, Manitou Island.

Glen Haven Dock
Glen Haven, Michigan

The Glen Haven Dock was built in 1865 by Charles C. McCarthy. Primarily used for loading milled lumber into vessels for delivery to other port towns. Once the dock was sold, it was used by its new owner David H. Day along with his two recently purchased steamers to create a freight and passenger service from Cheboygan to Chicago called the Northern Michigan line.

In the early 1920's the Glen Haven Dock was used to ship canned apples and cherries. The dock was closed in 193i but the pilings still stand tall, reminding us of its past.

James McBride
Sleeping Bear Point

The James Mcbride was a 121 ft. long brig launched on April Fools Day, 1848.

After nine years of ssrvice, a gale slammed her into the shoal off of Sleeping Bear Point.

J. S. Crouse
Glen Haven Dock

The J.S. Crouse gets covered and uncovered by sand over the years, with the boiler the only part still above sand.

The Crouse was an 89 ft. long "Rabbit" steamer built in Saugatuck,, Michigan in 1898. She was lost from fire on November 15, 1919, just after leaving the Glen Haven Dock. She was loaded with lumber and potatoes destined to Traverse City, Michigan.

Grace Williams
Manitou Passage

The Grace Williams was used in the late 1800's to salvage shipwreck cargo when Captain Francis Porter owned her.

The small "Rabbit" steamer was sold to Captain Eli Saxon Graham for hauling cargo around Michigan. On August 28, 1895 a gale swept Captain Graham off of the vessel near the Fox Islands and he was never found.

The next year on April 28, 1896, the Grace Williams was under tow and a gale struck the Manitou Passage, sinking her in 204 ft. of deep, cold water thereby preserving the vessel perfectly with minimal decay.

Schooner Rail
Northport, Michigan

This ship rail was used to launch schooners built by a Chicago ship builder that moved to Northport back in the 1950's.

Eagle
Northport, Michigan

Built in 1919 by Edwin Middleton in Northport, Michigan, the Eagle, right, was a small fish netting vessel. The invasive lamprey eel decimated the fish population and she was left tied to her dock during the winter of 1940, sinking her from snow accumulation.

Flora
Northport, Michigan

The Flora, left, was a small wooden tug. She was launched in Sagatuck, Michigan on October 25, 1889. Her boiler and hull are in shallow water off of Northport's public beach.

Francisco Morazan
South Manitou Island

The ocean going steel freighter Francisco Morazan was built in 1922 in Hamburg, Germany. She was delivering general provisions and ran aground in a snow storm on November 29, 1960 with no lives lost.

The bow of the Morazan was above water when it sank, but ice accumulation over long Michigan winters have submerged it.

Francisco Morazan engine room and boilers. The captain and crew of the Morazan where quickly rescued by the Coast Guard and transported to Traverse City, Michigan.